A Kid's Guide to Drawing™

How to Draw
Hanukkah Symbols

Christine Webster

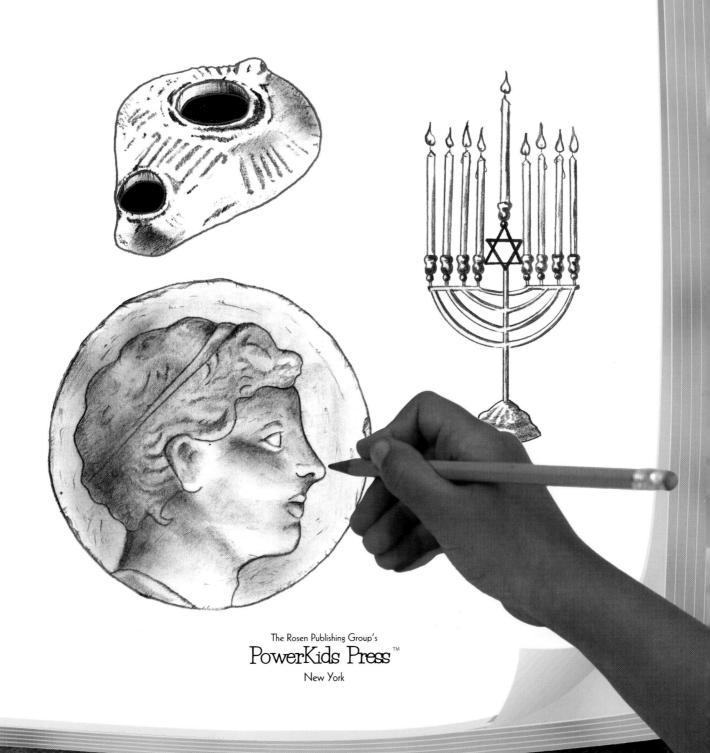

The Rosen Publishing Group's
PowerKids Press™
New York

To my parents, John and Helen

Published in 2005 by The Rosen Publishing Group, Inc.
29 East 21st Street, New York, NY 10010

First Edition

Editor: Orli Zuravicky
Book Design: Kim Sonsky
Layout Design: Mike Donnellan

Illustration Credits: Jamie Grecco
Photo Credits: Title page (hand) by Thaddeus Harden; p. 6 © Erich Lessing / Art Resource, NY; p. 8 © Mary Evans Picture Library; p. 10 © Robert Levin/CORBIS; pp. 12, 16 © Royalty-Free/CORBIS; p. 14 © Michael Matisse/Photodisc; p. 20 © Richard T. Nowitz/CORBIS.

Library of Congress Cataloging-in-Publication Data

Webster, Christine.
How to draw Hanukkah symbols / Christine Webster.
 v. cm. — (A kid's guide to drawing)
Includes bibliographical references and index.
Contents: Hanukkah symbols introduction — The Wailing Wall — Judah Maccabee — Antiochus IV — Ancient oil lamp — Menorah — Dreidel — Latkes — Gelt.
ISBN 1-4042-2727-X
1. Hanukkah in art—Juvenile literature. 2. Drawing—Technique—Juvenile literature. [1. Hanukkah in art. 2. Drawing—Technique.] I. Title. II. Series.
NC825.H35 W43 2005
743'.8896—dc22

 2003017592

Manufactured in the United States of America

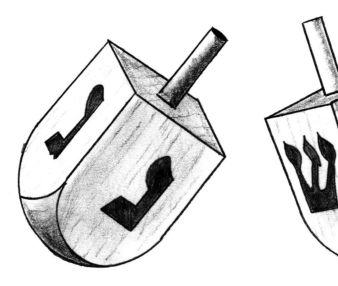

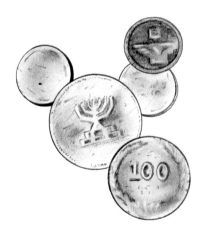

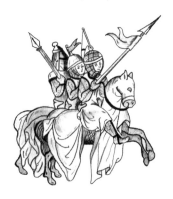

CONTENTS

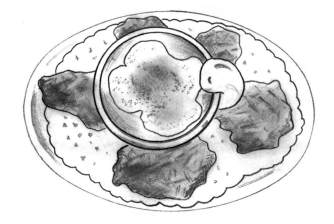

Hanukkah Symbols

Hanukkah is one of the most enjoyable holidays for **Jewish** people. It starts on the twenty-fifth day of the **Hebrew** month of Kislev in the Jewish calendar and lasts for eight days. Kislev usually falls in December.

More than 2,300 years ago, the Greeks took over Syria and Judea, present-day Israel, and ruled all who lived there. The king of Judea ordered the Jews to give up their **religion** and forced them to pray to the Greek gods. Though many Jews obeyed the king, a small group formed an army and fought back. After three years of fighting, they **defeated** their enemies. The Jews were finally free to practice their religion.

During the fighting, part of the Temple of Jerusalem had been destroyed. The Jews fixed up the Temple. Then they **rededicated** it to God by lighting the *Ner Tamid*, or **eternal** flame, of the Temple **menorah**. Afterward they **celebrated** for eight days. The holiday's name, Hanukkah, means "dedication" in Hebrew and refers to this rededication of the Temple.

From this story came a **legend**. It says that though only one day's worth of oil was found in the Temple,

it lasted instead for eight days. Over the years, this legend became part of the Hanukkah celebration.

The **symbols** of Hanukkah remind Jews of the **miracle** of their **victory** over the evil king of Judea. The story teaches them always to stand up for what they believe in and never to give up their rights to freedom. Families gather to play games, give each other presents, eat special foods, and light the Hanukkah menorah, also called a *chanukiah*.

In this book you will read about the history of the symbols of Hanukkah. You will also learn how to draw them. Follow the drawing directions given for each step. New steps are shown in red. Take a look at the drawing shapes and terms on page 22. Enjoy learning about Hanukkah and drawing your own Hanukkah symbols!

The supplies you will need to draw each Hanukkah symbol are:
- A sketch pad
- A number 2 pencil
- A pencil sharpener
- An eraser

Antiochus IV, Epiphanes

The cruel Greek king Antiochus IV was the ruler of Syria and Judea. He added "Epiphanes" to his name, which means "select of god." He forced his Greek **culture** on the Jews. He also put up **statues** of Greek gods throughout the Jewish community in Judea. The Jews did not believe in these gods, but they were forced either to pray to the gods or to face death. Antiochus's soldiers attacked the Temple of Jerusalem. They stole gold and silver **treasures**, built an **altar** for their own gods, and destroyed **holy** objects. They let pigs run loose inside the Temple and burned some parts of the **sacred** Jewish bible. During Hanukkah, Jews remember this evil king and celebrate his defeat. They think of the times when Jews were not allowed to practice their religion freely.

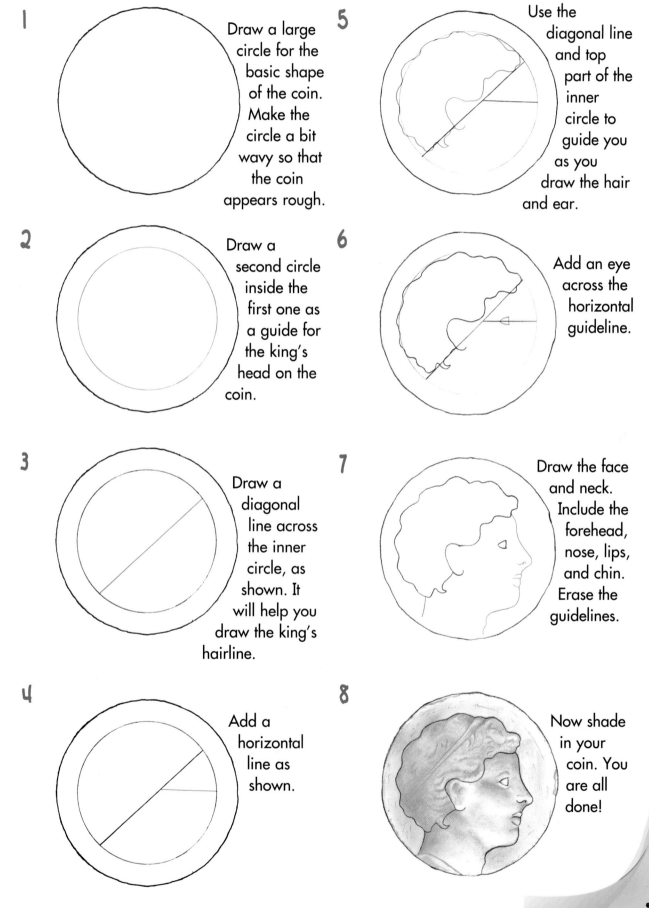

1 Draw a large circle for the basic shape of the coin. Make the circle a bit wavy so that the coin appears rough.

2 Draw a second circle inside the first one as a guide for the king's head on the coin.

3 Draw a diagonal line across the inner circle, as shown. It will help you draw the king's hairline.

4 Add a horizontal line as shown.

5 Use the diagonal line and top part of the inner circle to guide you as you draw the hair and ear.

6 Add an eye across the horizontal guideline.

7 Draw the face and neck. Include the forehead, nose, lips, and chin. Erase the guidelines.

8 Now shade in your coin. You are all done!

Judah and the Maccabees

When Antiochus forced the Jews to give up their religion, a Jew named Mattathius refused. He took his sons away from Judea and brought them to a cave in the mountains to **plot** a **rebellion**. He died soon after, and his son, Judah Maccabee, took over and formed an army. It was called the Maccabees. Although greatly outnumbered, the Maccabees fought hard for three years. In 165 B.C., they won the war. Today a big sports **competition** called the Maccabiah Games takes place in Israel. Jews come from all over the world to show support for Israel and to celebrate the Maccabees' spirit. During Hanukkah, Jews remember the Maccabees' victory of few over many as one of God's miracles. It teaches them to stay true to their beliefs.

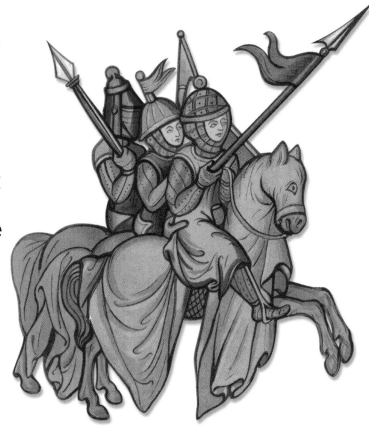

1 Draw two circles. Part of the left circle should be hidden behind the right circle. Draw a triangle with one point behind the left circle. These will be guides for the Maccabees' heads.

2 Draw the Maccabees' bodies and three right arms as shown.

3 Add two circles as shown on the right for the first horse's head. Draw another large circle for the horse's rear.

4 Using the circles as guides, create the shape of the horse's head and neck. Add two upside-down V shapes for ears.

5 Draw a big V shape under the men's bodies. Attach the V to the top of the circle for the horse's rear, as shown. Add the front and rear legs. Erase the circle guidelines.

6 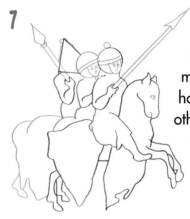 Draw a short line under the first rider to finish the horse's body. Finish the shape of the front rider by drawing his leg, foot, and robe. Draw the rest of the cloth on the horse.

7 Draw in the riders' faces, and the eye and mouth of the horse. Finish the other two horses' rears. Add the soldiers' blades and finish their hats as shown.

8 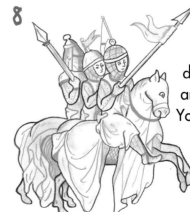 Now finish the drawing as shown and add shading. Your Maccabees are ready for battle, too!

The Ancient Oil Lamp

Long ago, Jewish law said that every temple had to have the menorah's eternal flame burning. The menorah was lit with an ancient oil lamp. When Antiochus's army attacked the Temple, they let the Temple's eternal flame burn out. After the Jews **purified** the Temple, they rededicated it to God by relighting the menorah. According to legend, upon returning from battle, Judah and his followers found only one day's worth of oil left in the ancient oil lamp. It would take eight days to make more oil. The lamp was lit with the remaining oil. This oil is said to have burned for eight days instead of one. This was just enough time to make more oil. The Hanukkah candles are left to burn out in honor of this story. The miracle of the oil is a symbol of the strength of the Macabees and the spirit of the Jewish people.

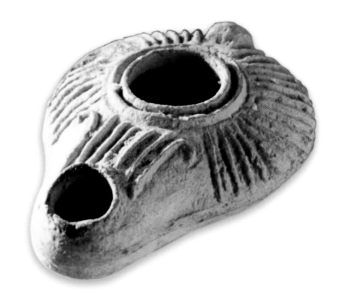

1

Draw a rough oval and a rough circle for the openings in the lamp.

4

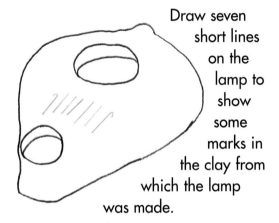

Draw seven short lines on the lamp to show some marks in the clay from which the lamp was made.

2

Draw the basic shape of the lamp as shown. Notice that it gets smaller at the bottom end.

5

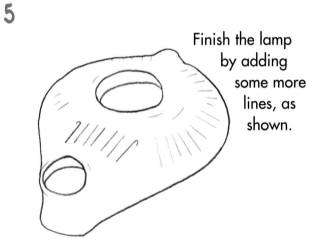

Finish the lamp by adding some more lines, as shown.

3

Add two curved lines inside the lamp openings. This shows that the openings are deep.

6

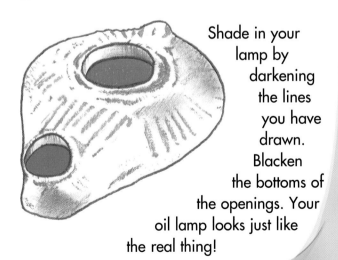

Shade in your lamp by darkening the lines you have drawn. Blacken the bottoms of the openings. Your oil lamp looks just like the real thing!

The Hanukkah Menorah

The Hanukkah menorah, called a chanukiah, is different from the ancient Temple menorah. The Temple menorah had seven candleholders, one for each day in the creation story. The chanukiah has eight candleholders of equal height and one more for the *shammash*, or helper. The shammash rises above the others in height and is used to light the candles. One candle is lit on the first night, two on the second night, and so on. Three blessings are said on the first night. The first two blessings are repeated for the next seven nights. Lighting the menorah helps Jews remember the first eight-day celebration of the rededication of the Temple. Today families celebrate by lighting the menorah, singing songs, and eating food.

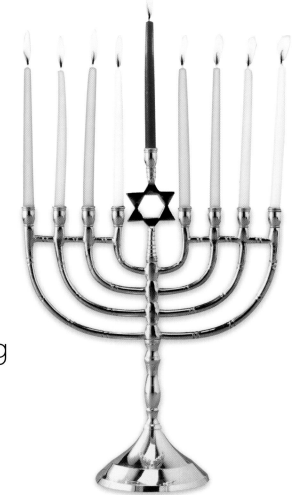

Start by drawing four narrow rectangles with pointed tops for the candles, as shown. They all should be equal in height.

2

Now add four more candles like the others. Leave a space in between the two groups of candles.

3

Add one more candle in the middle of the two groups of four. This one should rise above the others. Draw nine small circles, one under each candle.

4

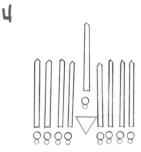

Draw a smaller circle under each circle you drew in step 3 to add to the shape of the candleholders. Draw a triangle, with a point facing down, under the middle candle.

5

Add a triangle with the point facing up on top of the first triangle to complete the Star of David. Connect the circles to the candles, as shown.

6

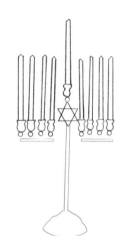

Erase any extra lines. Add two small rectangles under the two groups of candles. Add a long, narrow, vertical stem and add a base as shown.

7

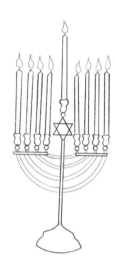

Draw eight curved lines, connecting each rectangle to the stem of the menorah. Draw lines connecting each candleholder to the rectangles. Add flames to each candle.

8

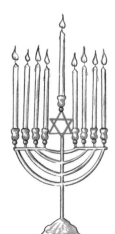

Just add shading and your menorah is ready for Hanukkah!

Gelt

Today's Hanukkah celebration includes presents, or gelt. Gelt means "money" in **Yiddish**. Some people believe that giving gelt began in Europe in the 1500s. Some people say that it began during the first dedication celebration. It is said that the Maccabees handed out the enemies' coins to the Jewish children to remind them of the victory over Antiochus. Long ago, gelt was the only type of Hanukkah present. Today's gelt comes in the form of small coin-shaped chocolates wrapped in gold foil made to look like the ancient coins. Money in the form of dollar bills and checks, as well as other presents, are all modern forms of gelt. These are given during Hanukkah as symbols of good fortune.

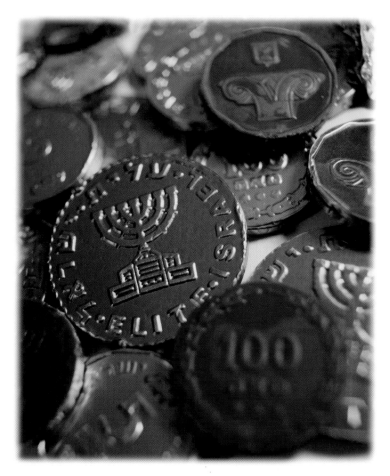

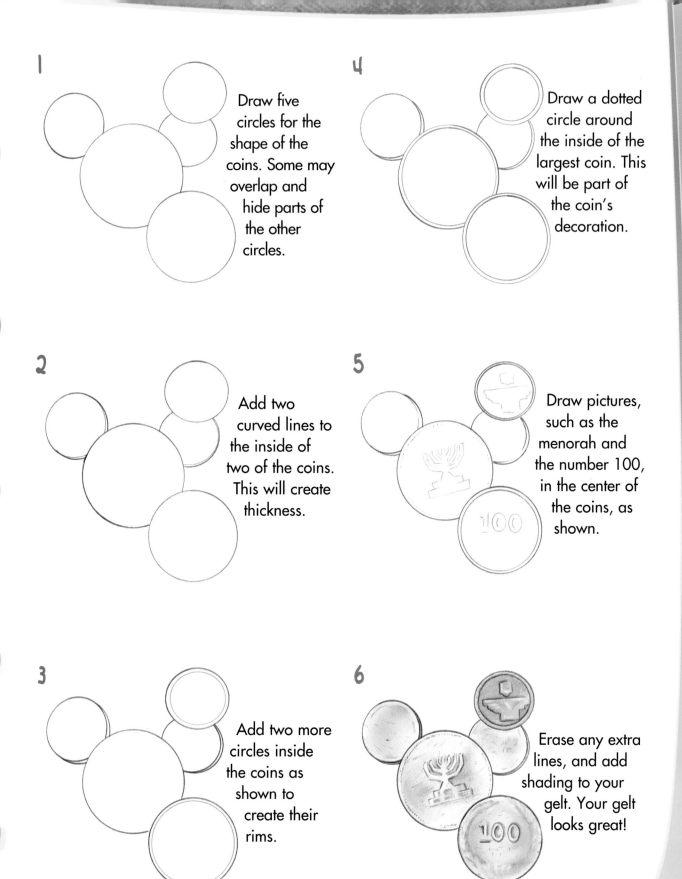

1

Draw five circles for the shape of the coins. Some may overlap and hide parts of the other circles.

2

Add two curved lines to the inside of two of the coins. This will create thickness.

3

Add two more circles inside the coins as shown to create their rims.

4

Draw a dotted circle around the inside of the largest coin. This will be part of the coin's decoration.

5

Draw pictures, such as the menorah and the number 100, in the center of the coins, as shown.

6

Erase any extra lines, and add shading to your gelt. Your gelt looks great!

The Dreidel

During Hanukkah, while the candles are burning, families sing and play games, like the dreidel game. A dreidel is a four-sided top that spins. On each of its sides, there is a Hebrew letter, as shown in the picture. Each letter stands for the first letter of each word in the Hebrew saying *Ness Gadol Haya Sham*, which means "A great miracle happened there." This refers to both the miracle of the oil and that of the Maccabees' victory.

Today dreidel games are played for a pot of candy, gelt, nuts, or raisins. Players spin the dreidel. Depending on what letter is up when the dreidel stops, the players either take nothing from the pot, take everything, take half, or put some of their own treats into the pot!

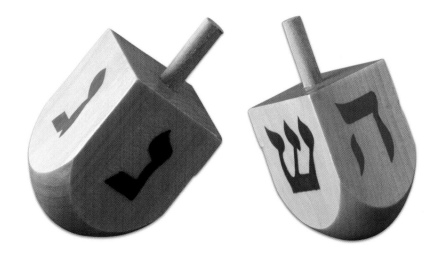

1

Draw two four-sided shapes, as shown.

2

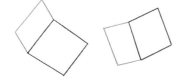

On the left side of each shape, draw three lines, as shown.

3

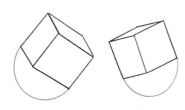

Draw two lines on the top of each shape to form a cube.

4

Draw two half circles on the bottom of each cube.

5

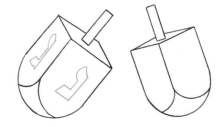

Draw two rectangles at the top of each dreidel. Draw two curved lines on the bottom of each dreidel, as shown.

6

Erase any extra lines. On the left dreidel, draw the first letter in the right box and the second letter in the left box.

7

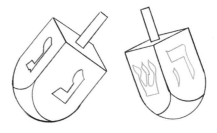

Draw the next two letters on the dreidel on the right.

8

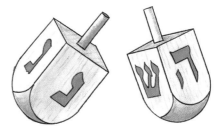

Add shading and light vertical lines on the dreidel to create a wood grain. Well done! Your dreidel looks great!

Latkes

Latkes, a popular Hanukkah treat, are pancakes that are made from potatoes. Hundreds of years ago, potatoes were a common and affordable food in Europe. They were harvested around the same time of year that Hanukkah was celebrated. European Jews began the **tradition** of making latkes in the 1600s.

Today latkes are made from grated potatoes, onions, flour, and eggs. The batter is shaped into small pancakes and fried in sizzling oil. The frying reminds the Jewish people of the legend of the oil that burned for eight days. Latkes are usually eaten with applesauce, sour cream, or sprinkled sugar. Families love feasting on this holiday treat during Hanukkah.

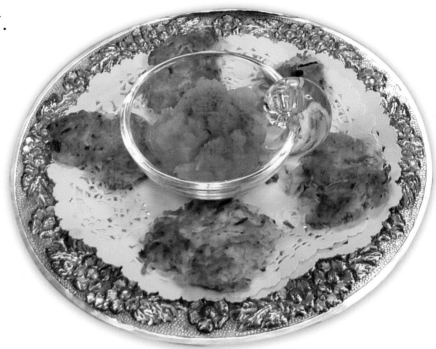

1

To create the basic shape of the plate, draw a large oval.

2

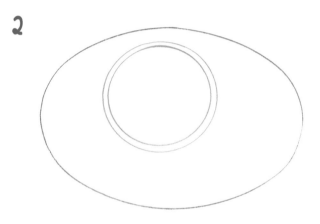

Now draw two circles, one inside the other, for the bowl.

3

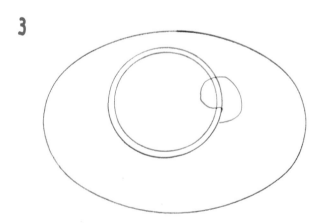

Add a handle on the bowl.

4

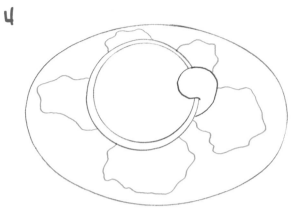

Erase the circle lines that overlapped with the handle. Add the basic shape of the five latkes.

5

Add some applesauce in the bowl. Draw a wavy line around the latkes for the napkin, which is covering the plate.

6

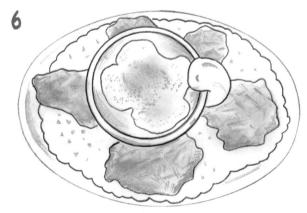

Add shading and you are all done!

The Western Wall

The Western Wall, which stands in the heart of Jerusalem today, is part of the same holy Temple that stood in Judea about three thousand years ago. Antiochus's army destroyed part of the Temple, but the Jews rebuilt it. Years later the Temple was destroyed again. Again it was rebuilt.

Today the Western Wall is the holiest symbol of Jewish history. Jews gather around the Wall to show respect to their people and religion. People write prayers for peace on scraps of paper and stick them in holes in the Wall for God to read. The Wall is a symbol of the strength of the Jewish people. Throughout history efforts were made to destroy both the Temple and the Jewish people, but both have **survived**.

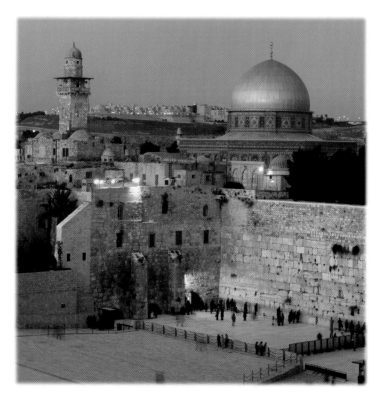

1

Draw the right side of the Wall using straight lines. Add the shape of the trees behind it.

2

Draw the shape of the left side of the Wall. Add two rectangular columns as shown, in the middle of the left Wall. Add lines to the columns for thickness.

3

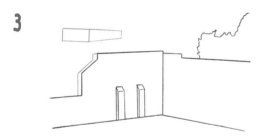

Draw two rectangular shapes above the left side of the Wall as shown. These will form a building in the distance. Add four lines to the shape of the Wall, as shown, for thickness.

4

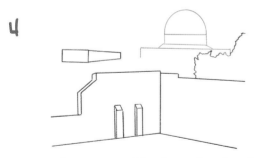

Next to the trees, add a base for the domed building. Then draw another horizontal line and two slanted sides, which attach to the base shape. On top of that draw a rectangle, and on top of that, draw a big half circle for the dome.

5

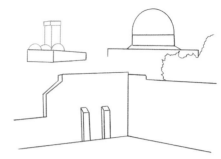

On top of the rectangular shapes above the left side of the Wall, draw a column, as shown. Draw three half circles at its base.

6

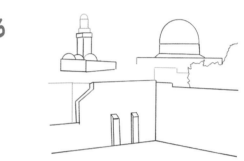

Add two more rectangular shapes and a half circle atop the column to form a building in the distance. Add two more walls with straight lines behind the Wall, as shown.

7

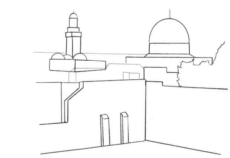

Add small lines to the top of each dome. Continue to add extra lines, as shown, to create other buildings in the distance.

8

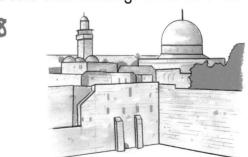

Now shade and add windows to the left side of the Wall. Good job!

Drawing Terms

Here are some words and shapes you will need to draw the Hanukkah symbols:

○ circle

∼ curved

／ diagonal

— horizontal

⬭ oval

▭ rectangle

shading

□ square

△ triangle

│ vertical

〜 wavy

Glossary

altar (OL-ter) A table or a stone used in religious services.

celebrated (SEH-luh-brayt-ed) To have observed an important occasion with special activities.

competition (kom-pih-TIH-shin) A game or test.

culture (KUL-chur) The beliefs, practices, and arts of a group of people.

defeated (dih-FEET-ed) Won against someone in a contest or battle.

eternal (ih-TUR-nul) Lasting forever.

Hebrew (HEE-broo) A language that was used by the ancient Jews and is still spoken in Israel today.

holy (HOH-lee) Close to God.

Jewish (JOO-ish) Being a Jew.

legend (LEH-jend) A story, passed down through the years, which cannot be proven.

menorah (meh-NOR-uh) A candleholder with seven or nine candles, used in the Jewish faith.

miracle (MEER-uh-kul) A wonderful or an unusual event said to have been done by God.

plot (PLOT) To plan out events or the way something will be done.

purified (PYUR-ih-fyd) Made pure or clean.

rebellion (ruh-BEL-yun) A fight against one's government.

rededicated (ree-DEH-dih-kayt-ed) Set apart for a special use again.

religion (ree-LIH-jen) A belief in and a way of worshiping a god or gods.

sacred (SAY-kred) Blessed by the church; highly respected and considered very important.

statues (STA-chooz) Images cut in clay, metal, stone or another material.

survived (sur-VYVD) To have lived longer than; to have stayed alive.

symbols (SIM-bulz) Objects or pictures that stand for something else.

tradition (truh-DIH-shun) A way of doing something that has been passed down over time.

treasures (TREH-zherz) Things of great worth or value.

victory (VIK-tuh-ree) The winning of a battle or contest.

Yiddish (YIH-dish) An eastern European language that was spoken long ago.

Index

Web Sites

Due to the changing nature of Internet links, PowerKids Press has developed an online list of Web sites related to the subject of this book. This site is updated regularly. Please use this link to access the list:

www.powerkidslinks.com/kgd/hanuksym/